Lie of the Land

The Secret Life of Maps

Langwärden
Sengwarden
tersiel
Eckwarder
Wilhelmshaven
Jade Bay
Ellenserdamm
Wremen
Langen
Neuenwalde
Burhave
Bremerhaven
Lehe
Stollham Blexen
Nordenham
Geestemünde
Wulsdorf
Ellwürden
Loxstedt
Lunc
Bokel
Sandstedt
Hagen
Wersabe
Uthlede
Brake
Oldenbrok
Quelenhorn
Rastede
Elsfleth
Neuenkirchen
Farge
Blumenthal
Vegesack
Berne
Lemwerder
Hude
Wüsting
Kirchhatten
Sandkrug
Osterholz
Bardahl
Bederkesa
Lamstedt
Himmelpforten
Ebersdorf
Geestenseth
Bremervörde
Beverstedt
Stubben
Kühstedt
Gnarrenburg
Selsingen
Rhade
Homberg
Breddorf
Zeven
Scharmbeck
Hamme
Worpswede
Tarmstedt
Wilstedt
Grambke
Kilienthal
Fischerhude
Ottersberg
Oldenburg
Osternburg
BREMEN
Waldbrück
Hemelingen
Hasbergen
Evers
Hatten
Hunteburg
Huchting
Delmenhorst
Ganderkesee
Brinkum
Achim
Weser
Dauerden
Langwedel
Dörverden
Sandkrug
Huntlosen
Sage
Dötlingen
Syke
Thedinghausen
Verden
Kirchlinteln
Groppenkneten
Ahlhorn
Harpstedt
Wahnebergen
Wildeshausen
Bassum
Bruchhausen
Vilsen
Cloppenburg
Visbek
Neue Bruchhsn.
Hoya
Emstek
Twistringen
Langförden
Goldenstedt
Asendorf
Bücken
Eystrup
Vechta
Barnstorf
Ehrenburg
Siedenburg
Wietzen
Vechta
Lohne
Kampen
Sulingen
Borstel
Drackenburg
Erichshagen
Dinklage
Rehden
Barenburg
Nienburg
Diepholz
Liebenau
Steinfeld
Bokel
Wagenfeld
Kirchdorf
Steyerberg
Landesbergen
Linsburg

Lie of the Land

The Secret Life of Maps

Edited by April Carlucci and Peter Barber

The British Library
2001

First published in 2001 by
The British Library
96 Euston Road
London NW1 2DB

© 2001 The British Library Board

British Library Cataloguing in Publication Data
A CIP record is available from The British Library

ISBN 0 7123 4751 8

Designed by Andrew Shoolbred
Printed in England by Balding + Mansell

Acknowledgements

This book is derived from the exhibition called *Lie of the Land: the Secret Life of Maps* at the British Library, July 2001 to April 2002. The exhibition was organised by former Map Librarian Tony Campbell and present Map Librarian Peter Barber, and based on work done by the curatorial and support staff of the Map Library and curatorial colleagues in the Department of Manuscripts and the Oriental and India Office Collections, as well as members of the Exhibitions staff, to all of whom our thanks and appreciation are extended.

For this book, we especially want to thank Map Library curators Surekha Davies, Debbie Hall, Robert Laurie and Tony Rosser, as well as members of the Publishing Office, Design Office, and Photographic Studio. We also gratefully acknowledge the co-operation of the Ministry of Defence, Defence Geographic Centre for use of maps donated to or deposited with the British Library; Mark Evans for use of his father's POW maps; and Dr Christopher Board, formerly of the London School of Economics. As we were unable to ascertain the present copyright-holder of the Soviet military map of Thurrock before going to press, we would welcome that information for inclusion in any later printing of this catalogue.

Introduction

It is easy to assume that, as a result of the sophistication and accuracy of measurement now possible thanks to modern technology, maps are tantamount to the reality. Can this be so? The world is round. The map is, usually, flat. So any attempt to convey the world truthfully in all respects on a map is doomed to failure. You can either, to varying extents, depict the shapes of the landmasses correctly, as happens with the Mercator Projection, or you can show their relative sizes correctly, as with the more recent Peters Projection. You cannot get both right simultaneously except on a globe. This mimics reality, but, in common with all maps, it cannot, whatever its size, truthfully convey the complexity and chaos that is reality.

The mapmaker has to simplify, selecting only those elements of reality that he or she considers to be necessary to serve their, or their master's, purpose. Sometimes, indeed, to achieve this end, the mapmaker has to show features such as borders (items 14, 32)*, differing levels of wealth or 'civilisation' (items 32, 38)and even paradise (items 45, 69) that have no physical existence. Subjectivity enters into cartography whether on the most recent satellite-based, digital mapping demonstrating near total accuracy in measurement or on older Western and non-European maps where the subjectivity is more apparent and measurement only approximate or even non-existent and whose creators have often been castigated for their apparent ignorance, credulity and lack of ability by modern Western users.

Usually the subjectivity of maps is concealed because the user shares the values of the mapmaker, almost instinctively agreeing on what is or is not important. The maps needed by Lord Burghley for the defence of Kent (item 8) or

Lancashire (item 9) from invasion by Catholic Spain in the 1580s and 1590s, necessarily emphasise the locations of beacons and, in the case of Lancashire, of potentially disloyal Catholic gentry families. At the same time they omit much information such as land-use and the size of towns, that in other contexts could have been considered more important.

Occasionally, however, the mapmaker's values will be unconventional and the resulting map could cause outrage, as when in about 1970 a postcard produced in Damascus by a Syrian nationalist showed 'Syria' extending from the Mediterranean to Iran (item 102). More often the 'dishonesty', or what some might perceive as such, lies in the controversial combination of elements that are, individually, true, or in the omission of elements that are generally considered to be essential. Thus in the 1820s a liberal-minded Irish colliery owner chose to indicate places where the military attacked, tried and hanged Irish insurgents and not the sites where the insurgents made trouble (item 17), while a socialist mapmaker of the 1920s, in line with his Marxist beliefs, showed much of Scandinavia as British colonies (item 84).

Indeed the most fascinating and valuable aspect of the subjectivity of all maps lies in the mirror that they provide into the mentalities of mapmakers and their societies. One gets a sense of the priorities of a mid-eighteenth-century City businessman when one sees a specially commissioned map screen adorned with views of London landmarks and maps of the world, of Great Britain, of the American colonies and of American and European battlefields (items 39, 81). A clear idea of the sophistication of late medieval Europeans, who easily distinguished between the scientific, the religious-traditional and the utilitarian, can be gained from three very different world maps – Ptolemaic (item 105), symbolic TO (item 107) and maritime ('portolan') charts (item 106) – that were available in the late fifteenth century. Often maps illustrate the aspirations and dreams of the people who commissioned or created them, be they utopian Chartist estates, like O'Connorville, now Heronsgate, near Rickmansworth (item 49), suburban paradises like Hampstead Garden Suburb (item 59), colonies like Pennsylvania (item 74), or the Buddhist sacred lake in the Himalayas (item 71).

Often maps will reveal more about attitudes and objectives than their makers would normally trust to put into writing. They have repeatedly put their countries at the centre of the world – China (item 66), Great Britain (item 84), Australia (item 75), Cyprus (item 36). An English surveyor, simultaneously working for the Cape Colony government and for the mining company DeBeers, decorated his map of the siege of Kimberley (item 29) in 1900 with pictures of Boers impaled on the spikes of the compass rose. In a world map of 1815 (item 38) and maps of London of 1889 (item 4), English mapmakers chose to depict Judaism and extreme poverty in London in black. The adoption of particular symbols and graphics can also lead maps to inflame passions, as with the brutal simplicity of an effective propaganda map (items 80, 95). Conversely, sometimes sober symbols can reveal an inability or refusal to comprehend, as on an Allied map of early 1945 for dealing with displaced persons (item 13) which demonstrates that at that time the Allies made little distinction between work camps and concentration camps such as Bergen-Belsen, or the straight line drawn on a late-nineteenth-century official map of Africa (item 27) between what is now Kenya and Tanzania, which separated people of the same tribe.

Maps can also tell particular stories. The 1945 printing of aerial photographs of Germany on the versos of 1942 German occupation maps of Scotland provides mute testimony of the fortunes of war (item 10). One can see the pride that the Dutch took in hosting an international peace conference in the beauty of the bird's-eye view that was commissioned of the house and gardens where the negotiations took place in 1697 (item 53). On a more personal note maps can reveal vanity: in the detailed plan and view of an unpretentious suburban house and garden that was once framed for display (item 58); in estate maps like those showing the owner's home at the centre (item 43); by the grouping of detached landholdings pieced together to create the impression of a greater whole (item 115); or in those containing spectacular, but useless, demonstrations of mathematical skill (item 76). On a more serious note, the fact that Siegfried Sassoon chose to keep the map fragment showing the French trenches where he had served in 1916 suggests the importance he attached to his searing experiences there (item 73).

Whatever their ostensible purpose, however, all maps need detailed scrutiny before they can be properly understood. One of the earliest world maps on the Mercator Projection turns on closer examination into a piece of religious-political propaganda on behalf of the allies of the nascent Dutch Republic (item 110); a strange-looking depiction of ships is revealed to be a blueprint for smuggling one of Henry VIII's wives into England (item 121). Two very different-looking maps, one Arab (item 55) and the other medieval English (item 56), one centred on the Persian Gulf and the other on the Mediterranean, on closer examination reveal their common Graeco-Roman source. An academic-looking map of immigration into the USA turns into a Nazi aid for keeping America out of the Second World War (item 22). An apparently utopian map (item 118) of a united Europe of 1867 turns out on closer inspection to be distinctly French! Quality can also be appreciated if you take a closer look: at the precocious interest in industrial production to be found in Philip Apian's mid-sixteenth-century map of Bavaria (item 119); in the exquisite depiction of detail in the enormous map of Scotland prepared by Paul Sandby, 'the father of English watercolour', in the early 1750s (item 33); or in the beautiful map of China created in a light-hearted moment by one of the best-known Japanese artists of all time, Hokusai, in 1840 (item 130).

There is, then, much more to maps than meets the eye. It helps to account for the growing interest in them by historians, psychologists and literary specialists as well as the geographers and collectors who, until recently, seem to have had maps all to themselves.

* Please refer to pages 61–64 for a complete listing of items in the exhibition *Lie of the Land: the Secret Life of Maps*.

Chinese globe, 1623

This is the earliest-known Chinese globe. It was constructed in Beijing by Yang Ma-no and Long Hua-min. But this is deceptive. The makers were Jesuit missionaries (real names Manuel Dias and Nicolo Longobardi); like others of their Order they gained the respect of the Chinese authorities by sharing their knowledge of European sciences.

The text includes an explanation of the theories behind the construction of the globe, including the concepts of latitude and longitude, and describes how the observation of solar and lunar eclipses can show that the world is round. It goes on to explain that climate varies throughout the world. The end of the text states that the globe has been made as a result of study and deduction from facts, and wonders what is the response of 'the creator of all things'.

Most Chinese world maps of this period (like the one illustrated on page 39) show China at the centre with minimal geographical information for the rest of the world. The impact of seeing for the first time a globe, showing everywhere in proportion and in its place, can scarcely be over-estimated.

Yang Ma-no and Long Hua-min [i.e. Manuel Dias and Nicolo Longobardi]. [*Chinese terrestrial globe*]. [1623]. Maps G.35.

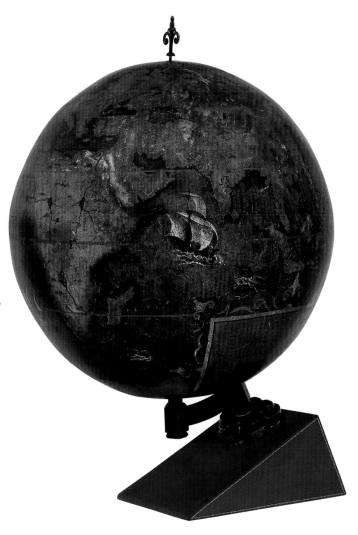

Drawing the line

For centuries maps have been used as a means of administrative, social and military control. They have been used to plan bombing raids and invasions – illustrated here by the Zone map of Dresden (item 26, page 26) and the Zone map guide (item 25, page 27) produced by the British military a year before the aerial raids on the city in 1945, and by the map of Plymouth, England (item 21, pages 18–19) produced by the German military in 1942 with a view to the invasion of Britain. Maps have been instrumental in helping to suppress and promote religious, ethnographic and political views, such as the map of Munster of 1828 (item 17), produced during a period of violent agitation for Catholic emancipation in Ireland which shows clear sympathies towards the Catholic population; and the ethnic map of Slovakia (item 11, page 16) where official Czechoslovak population statistics were used to aid anti-Semitic legislation brought in under the Nazi occupation, as well as the ethnographic map of Czechoslovakia which illustrates the Nazis' justification for the annexation of the German-speaking population in the Sudetenland (item 16).

Peoples' lives have been affected by lines drawn on maps to define boundaries. On a sheet of paper empires divided up Africa with a straight line without regard for local topography or populations (item 27). How sensitive certain maps could be to international negotiations is clearly illustrated by the 'Red-lined' map of North America (item 32, pages 12–13) which was originally produced by the British in 1755 and later used during negotiations following the American War of Independence which led to the Treaty of Paris, but then was hidden from prying eyes until 1896 for fear of losing acquired land. There are maps showing governments' control over where people could live, such as the maps of the Warsaw Ghetto in 1944 (item 28) and of Nagasaki in the 1680s (item 30).

Maps have been instrumental in the saving or loss of lives and property, such as the General Strike map produced by the Ordnance Survey for the British military in 1926 (item 20, pages 20–21), used by the government to prepare for and suppress expected riots; and maps that were used by the military to wage war (German military bombing maps over England, item 24). Especially telling of the implications of drawing a line – and how the line may not be permanent – is the Luftbildstellungskarte (item 10): on one side a German military re-printing of a map of the Orkney Islands in Scotland, with special information overprinted to aid invasion in 1942, while on the other side a sloppy aerial photo mosaic showing the Russian encroachment on Germany's Eastern Front in 1945, a true indication of the changing fortunes of war.

The 'Red-lined' map, 1782

This map by John Mitchell, originally published in 1755, was still considered the most authoritative map of North America in 1782. This copy, part of the immense private map collection of King George III, became known as the 'Red-lined' map when it was used during the negotiations of the Treaty of Paris which recognised the independence of the United States of America at the end of the American War of Independence (1776–83). The red lines illustrate interpretations of the clauses of earlier treaties. They were added by Richard Oswald, the secretary to the British delegation in Paris and a good friend of American patriot Benjamin Franklin, for the private use of his British colleagues. The final treaty line of 1783 was much more favourable to the British. Fear of revealing the earlier line and of being compelled to surrender large tracts of Canadian land to the United States led successive British governments to forbid unauthorised access to the map until 1896. The veil of secrecy which shrouded the map resulted in the ironic situation whereby this most crucial of documents in American history was virtually unknown in the United States until the twentieth century. Decades after it came to light, it was still being used as evidence in internal boundary disputes in both the United States and Canada.

Detail above: The thin red line south of the St. Lawrence River surrounds a section of land, now part of Canada, that the British were prepared to cede to the Americans.

Opposite: John Mitchell. *A map of the British and French Dominions in North America* [*the 'Red-lined map'*]. Revised edition. London, 1775, with manuscript additions, [1782]. Maps K.Top.118.49.b.

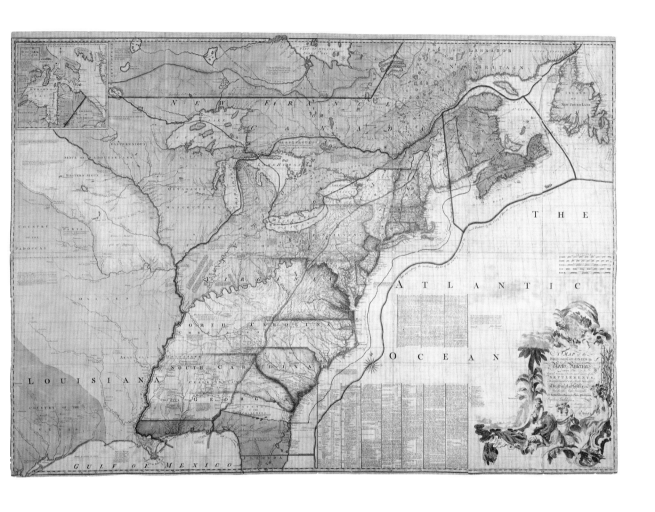

13

The Roy Map of Scotland, *c.* 1755

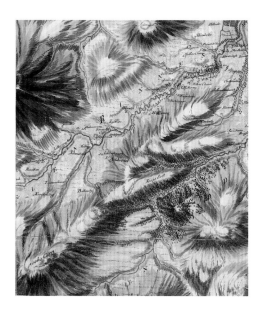

The military survey of Scotland (1747–55), arguably the British Library's greatest cartographic treasure, is usually attributed to William Roy, who would later found the Ordnance Survey. It was carried out under the supervision of the Board of Ordnance in the wake of the 1745 Jacobite uprising and was intended to ensure there was no repetition. Various versions survive, all kept in the Library. None was ever published.

While Roy was probably responsible for the topographical detail and lettering, the marvellous hill drawing and minute depiction of towns and estates in the lowlands were the work of Paul Sandby, 'the father of English water-colour art'. Since no large-scale surveys were carried out in Scotland until the nineteenth century, the Roy Map remains invaluable for historical and genealogical research. It is also much consulted when attempts are made, even today, to define the precise border between England and Scotland.

For all its beauty and accuracy, Roy's survey was first and foremost an instrument for defending and controlling a country from a distance. It was this consideration that led the Westminster Parliament to acquiesce when presented with the cost of producing it. Similar reasons led absolutist foreign rulers in this period, including George III as Elector of Hanover, to commission very detailed maps of their lands.

In England itself, however, the situation was different. The country seemed to be protected from invasion by the surrounding seas, and the nobility and country gentlemen who dominated Parliament were deeply resentful of snooping by agents of central government such as surveyors. As a result, and despite William Roy's pleas, money for a detailed survey of England was never made available – until the 1790s when the threat of French invasion forced a rethink. The Ordnance Survey began its work with a survey of Kent, the county that was most threatened. It was only in the twentieth century, however, that the official mapping of England reached the level of detail about land ownership that had been attained in less secure and more autocratic European states some 200 years earlier.

William Roy. [*Fair copy drawings of the military survey of Scotland.*] [*c.*1755]. Maps C.9.b.

N.B. This illustration is from the 'fair copy' version of the Roy Map in order to show its fine detail, and is different from the reduced version exhibited – the 'fair copy' would have been too large to hang on the wall of the gallery!

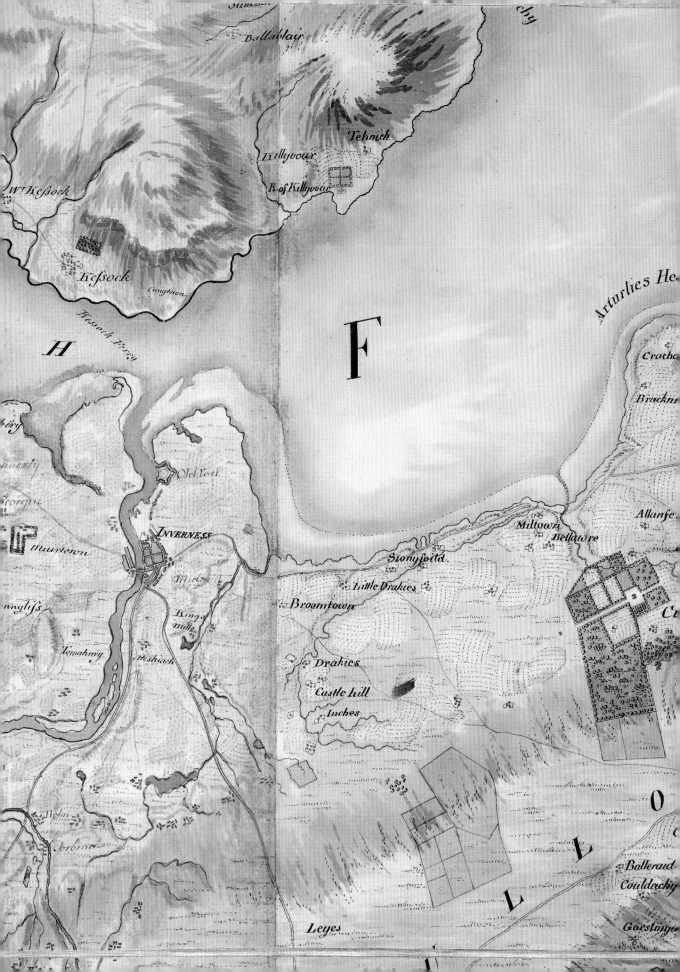

Ethnic map of Slovakia, 1941

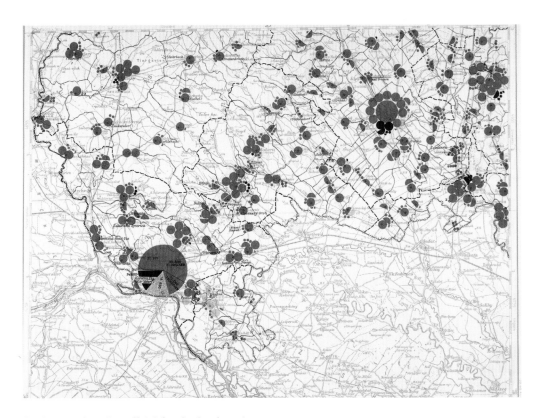

On this map, based on official Czechoslovak statistics, the numbers for the different racial groups, identified by colour, are shown by the sizes of the circles. It appears a model of academic analysis but it was actually a blueprint for action. Its German makers chose black to indicate the Jews (Juden) and the gypsies (Zigeuner). Nazi 'advisers' had already been seconded to help the Slovak president, Monsignor Tiso, with his anti-semitic legislation. The inscription to the right of the title reads, chillingly, 'For official use only'. Deportations of Jews and gypsies to extermination camps started the following year.

Wilfried Krallert. *Volkstumkarte der Slowakei.* Vienna, 1941. Maps Y.1911.

Plan of Wellington, New Zealand, 1840

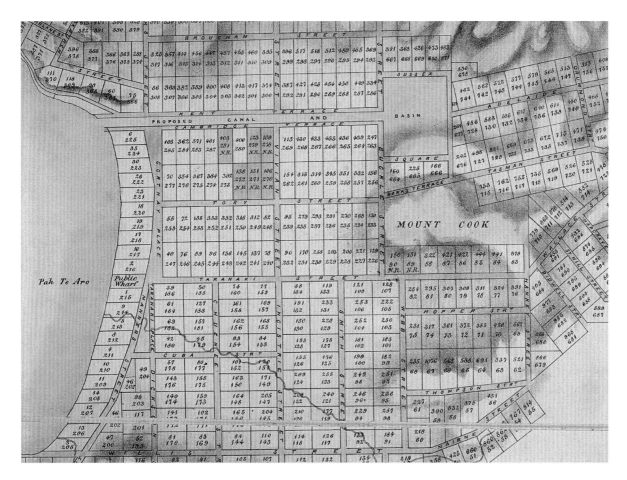

The New Zealand Company, promoting the city of
Wellington in 1840, envisioned a remarkably even
street grid, paying little attention to hills, moun-
tains and a complicated coast line. There are many
more straight lines on the map than are justified
by the physical lie of the land. But an even and
square grid gave the appearance of organisation
and order, two qualities deemed very important to
potential settlers.

Plan of the town of Wellington, Port Nicholson, the first and
principal settlement of the New Zealand Company.
[London], Smith, Elder and Co., 1840. Maps 92540.(7.).

German map of Plymouth, England, 1941

This map of Plymouth was produced by the German military in 1941. It identifies such points of interest as civil and military installations, industrial works and bridges. It was intended for use by the Germans after an invasion of Britain. Although Hitler had by 1941 shifted his focus eastward, the military wanted to be prepared. On careful inspection, you can see that the Germans colourfully printed their invasion information over a standard Ordnance Survey map of the period, and that much of the crucial information actually appears on the OS map beneath. The result leaves you wondering if the Germans had spies on the ground in Plymouth, or just good map readers working in Berlin. This was one of a series of such maps of British towns and cities produced by the Germans at the time.

Germany, Generalstab des Heeres, Abteilung für Kriegskarten und Vermessungswesen (IV. Mil.-Geo.). *Militärgeographische Einzelangaben über England. Stadtplan von Plymouth*. Berlin, Generalstab des Heeres, 1941. Maps 47.g.14.

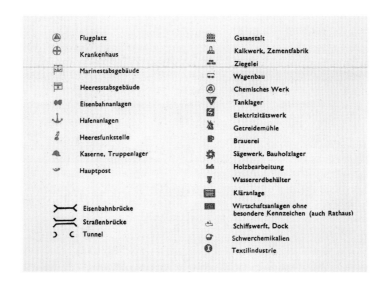

Flugplatz		Gasanstalt	
Krankenhaus		Kalkwerk, Zementfabrik	
Marinestabsgebäude		Ziegelei	
Heeresstabsgebäude		Wagenbau	
Eisenbahnanlagen		Chemisches Werk	
Hafenanlagen		Tanklager	
Heeresfunkstelle		Elektrizitätswerk	
Kaserne, Truppenlager		Getreidemühle	
Hauptpost		Brauerei	
		Sägewerk, Bauholzlager	
		Holzbearbeitung	
Eisenbahnbrücke		Wassererdbehälter	
Straßenbrücke		Kläranlage	
Tunnel		Wirtschaftsanlagen ohne besondere Kennzeichen (auch Rathaus)	
		Schiffswerft, Dock	
		Schwerchemikalien	
		Textilindustrie	

Stadtplan von Plymouth

Mil.-Geo.-Bearbeitung nach den bis zum 1.8.1941 vorhandenen Unterlagen

Die Höhen sind in englischen Fuß angegeben

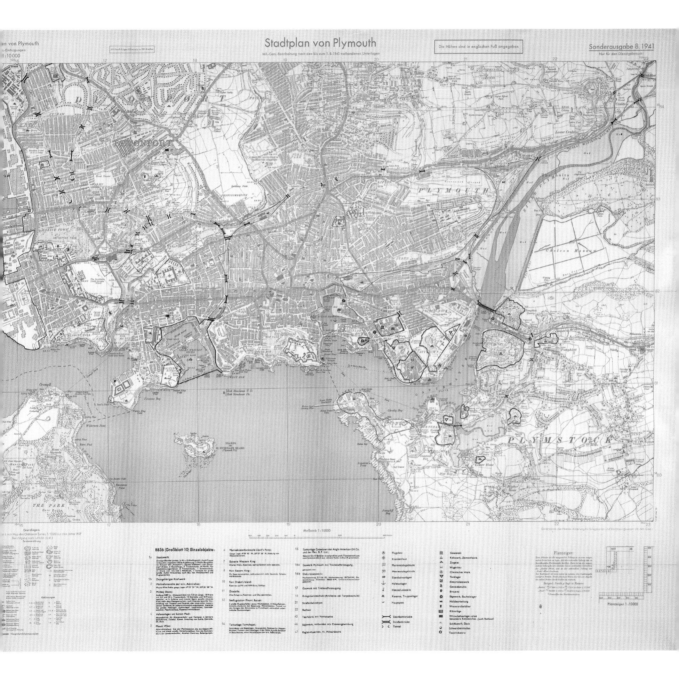

Maßstab 1 : 10000

8836 (Großblatt 10) Einzelobjekte:

19

Secret map of London, 1926

The General Strike of May 1926 was the closest Britain came to an insurrection in the twentieth century. Called by the Trades Union Congress in support of the coal-miners, the Strike lasted only nine days but brought large parts of Britain, including London, to a standstill. The military were called in – armoured cars were seen in the capital. The Government feared the outbreak of complete anarchy and class war. Secret correspondence between the War Office and Ordnance Survey indicated that a special map of London had been prepared beforehand to show facilities which authorities considered 'vulnerable', as well as 'control' points in case of trouble – although these could indeed be one and the same. Even the existence of this map itself was kept secret, and all copies of it were believed to have been destroyed until this copy was presented to the British Library by the Ministry of Defence in 1995.

Great Britain, War Office, General Staff, Geographical Section. *The County of London, G.S.G.S. no. 3786A, [west sheet]. Scale 1:20 000*. Ordnance Survey, 1926. Maps CC.5a.170.

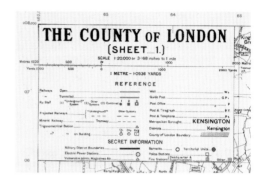

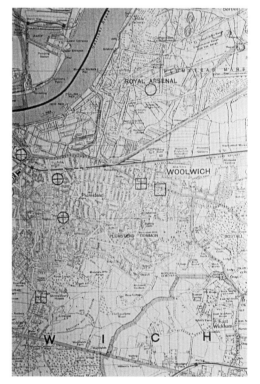

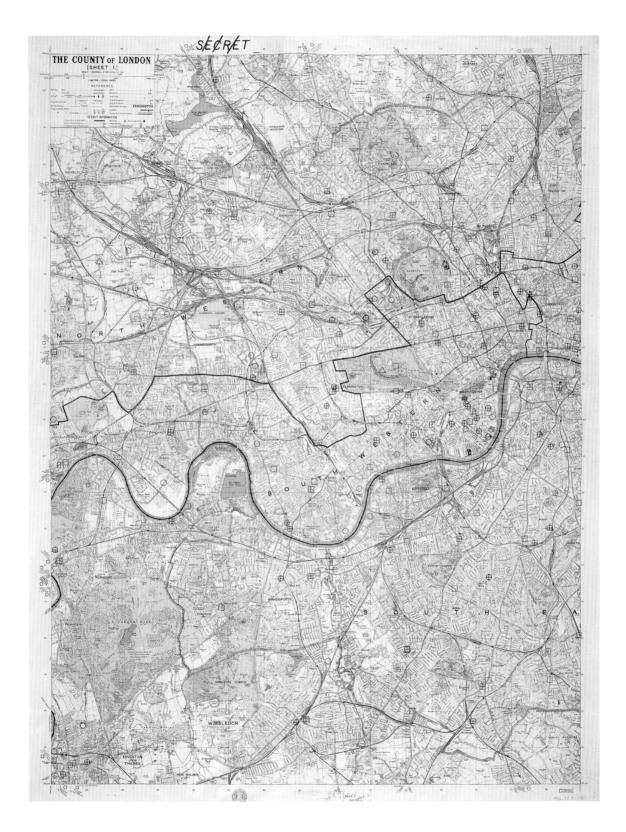

THE COUNTY OF LONDON
[SHEET 1]

21

Plans of St Paul's Cathedral area, London, by Charles Goad, 1886 & Ordnance Survey, 1894–95

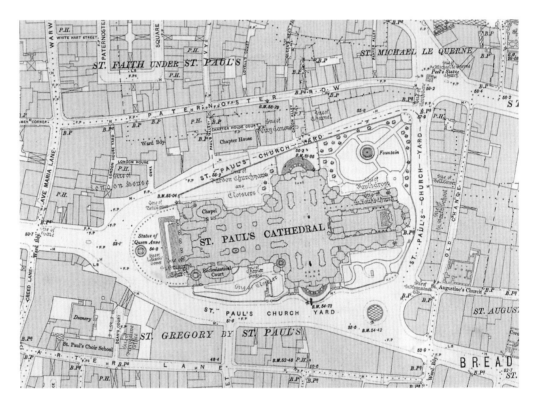

Two maps of an area can provide very different information if they were made for different purposes. The area around St Paul's Cathedral, London, is shown here in two such maps. The largest-scale plan produced by the Ordnance Survey provides, for example, precise measurements, some internal architectural details and boundary information – and does so in black and white. By contrast, fire insurance plans like this one issued by Charles Goad, use an even more detailed scale, concentrate on information required to assess insurance risk and use colour coding to show more information than just outlines. The insurance plan is about twice the scale of the Ordnance Survey map and identifies the use and ownership of property, internal and external building materials, street widths and property numbers – information used by the insurance assessor to determine the likelihood of a fire and the potential for damage. The explanation of the colours is as follows: red – brick buildings, yellow – wooden buildings, dark blue – stone buildings, light blue – low level skylights, purple – high level skylights.

Above: Ordnance Survey. *Plan of London*. Extended Series, sheet VII 65. 1894–95. Scale: 1:1056 (5 feet to 1 mile). Maps O.S.

Opposite: Charles Goad. *Insurance plan of City of London*. Vol. 1, sheet 10. Scale: 1:480 (40 feet to 1 inch). London, 1886. Maps 145.b.22.

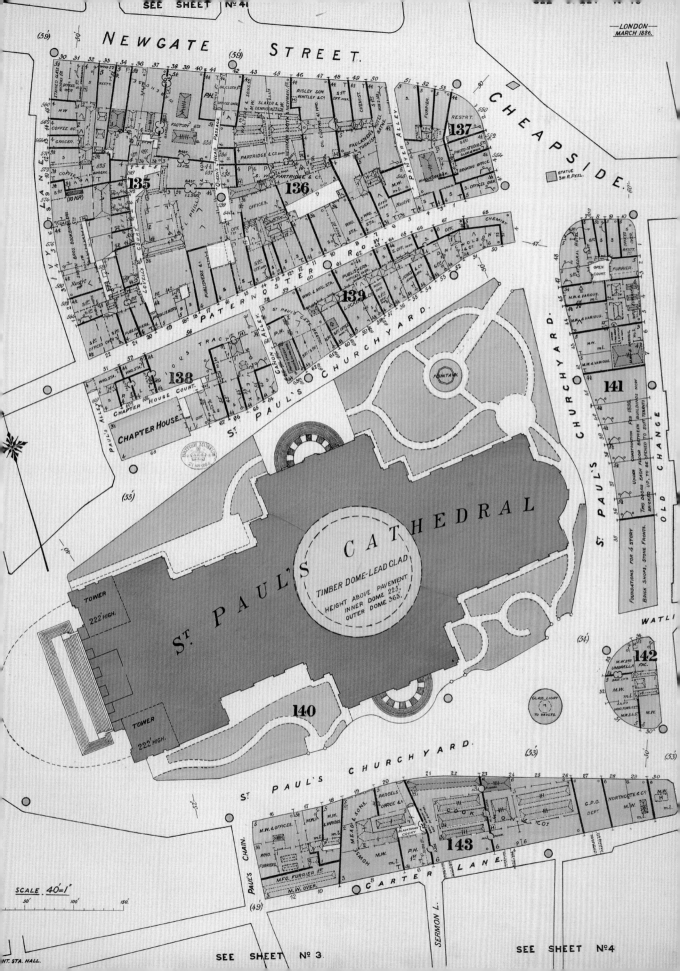

Chart of the west coast of South America by William Hack, 1698

Cartographic knowledge can equal power. This was probably visibly evident on the face of the captain of the *Rosario*, which was intercepted in 1680, as he threw overboard confidential charts detailing Central and South America's Pacific coast. Bartholomew Sharpe was the captain of the English privateer that captured the volume of charts, and its perceived value to the English government was sufficient to save him from the gallows on his return to London. William Hack, a chartmaker, produced manuscript copies of the volume for around 20 years. These helped keep alive English ambitions in the Pacific.

'A general draught of the contents of this manuscript it being a description of the sea coast from the mouth of California to the straits of Lemaire' from: William Hack. *Description of the Coast & Islands in the South Sea of America*. 1698. Maps 7.Tab.122.(1).

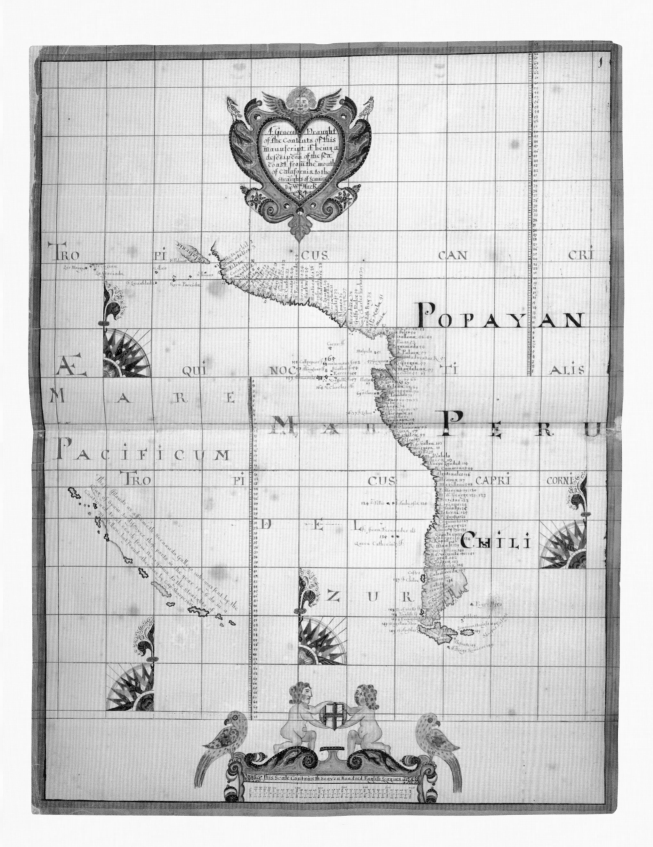

Zone map of Dresden and guide, 1940s

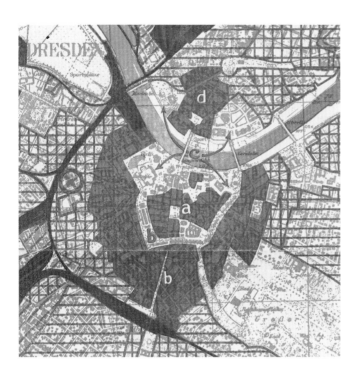

Maps provide valuable insights into past events well illustrated here by two items from one of the most costly conflicts in human history, the Second World War.

The guide was produced to accompany a series of Zone Maps compiled by the British Air Ministry to support the Allied air campaign against urban targets in Germany during the War. Zone Maps were also produced for large towns throughout Italy and major occupied cities in other countries of central Europe but the guide seen here focuses on the offensive waged against German cities, a strategy at the heart of the Allied air campaign to destroy the Nazi war machine. Air photographs illustrate the various kinds of building concentration and population density in typical large German cities as well as in the industrial Ruhr (shown on the right-hand side of the guide) and their vulnerability to different kinds of bombing (high explosive or incendiary). Linked to these by black arrows, the central coloured diagram shows how these areas are represented on the Zone Maps themselves, as is shown on the actual Zone Map of Dresden. It displays a range of targets, from the highly built-up city centre (solid red) to the less built-up suburban areas (red vertical lines). The map also pinpoints the locations of industries and key utilities. That the potential human toll of heavy aerial bombing has been considered is implied by some of the accompanying observations. Fig. 3 illustrating Zone 2a to the left of the guide states: 'Tenement buildings in the inner *residential* zone may be burnt out under heavy I.B. [incendiary bomb] attack. The effect of H.E. [high explosive] is not hard to imagine.'

The Zone Map of Dresden was produced in December 1943, over a year before the air raids that destroyed the city in February 1945. Almost 2000 Allied bombers dropped 3000 tons of bombs, including 650,000 incendiaries, on the centre of Dresden, resulting in a fire-storm that virtually erased the city and killed, according to various estimates, between 35,000 and 135,000 people.

Above: Great Britain, Air Ministry. *Zone maps, series GSGS 4399 (Dresden sheet).* 1943. Maps MOD GSGS 4399.

Opposite: Great Britain, Air Ministry. *Zone maps, typical examples of city zones, A.M. 407/2.* [194-]. Maps X.5429.

ZONE MAPS
TYPICAL EXAMPLES OF CITY ZONES

To give the user of Zone Maps a better idea of what the Zones mean this illustrated sheet is issued. It should be studied in conjunction with the Introductory Notes. Since the Ruhr has distinctive differences from the larger German towns, separate examples are given.

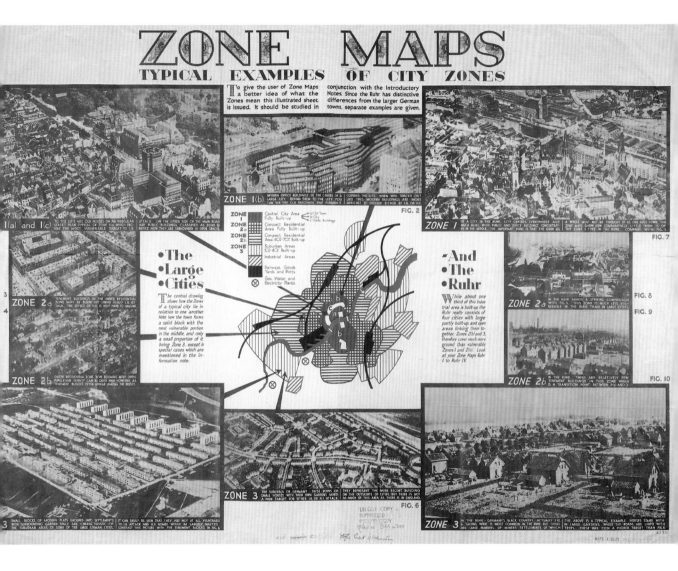

1(a) and 1(c) TO THE LEFT ARE OLD HOUSES ON AN IRREGULAR STREET PLAN TYPICAL OF ZONE 1(a) WHICH PROVIDE THE MOST VULNERABLE TARGET TO I.B. ATTACK. ON THE OTHER SIDE OF THE MAIN ROAD ARE PUBLIC BUILDINGS, CLASSIFIED AS ZONE 1(c). NOTICE HOW THEY ARE SURROUNDED BY OPEN SPACES.

ZONE 1(b) MODERN OFFICE BUILDINGS IN THE CENTRE OF A LARGE CITY. BEHIND THEM TO THE LEFT, YOU CAN SEE THE OLD BUILDINGS THAT FORMERLY COVERED THE SITE. WHEN WELL SPACED OUT LIKE THIS, MODERN BUILDINGS ARE MORE DIFFICULT TO DESTROY EITHER BY I.B. OR H.E. **FIG. 2**

ZONE 1 OF A CITY IN THE RUHR. CITY CENTRES EVERYWHERE ARE MUCH ALIKE WITH PUBLIC AND OFFICE BUILDINGS CONCENTRATED IN THE MIDDLE. THE IMPORTANT POINT IS THAT THE RUHR AS A WHOLE MUST NOT BE THOUGHT OF AS ONE HUGE TOWN. THE ZONE MAPS SHOW HOW COMPARATIVELY LITTLE THERE IS OF THE ZONE 1 TYPE IN THE RUHR. COMPARE WITH FIG. 1. **FIG. 7**

ZONE 2a TENEMENT BUILDINGS IN THE INNER RESIDENTIAL ZONE MAY BE BURNT OUT UNDER HEAVY I.B. ATTACK. THE EFFECT OF H.E. IS NOT HARD TO IMAGINE.

ZONE 2b OUTER RESIDENTIAL ZONE NOW BECOMING MORE OPEN. POPULATION DENSITY CAN BE QUITE HIGH HOWEVER, AS TENEMENT BLOCKS OFTEN APPEAR AMONG THE HOUSES.

The Large Cities

The central drawing shows how the Zones of a typical city lie in relation to one another. Note how the town forms a solid block with the most vulnerable portion in the middle, and only a small proportion of it being Zone 3, except in special cases which are mentioned in the Information note.

ZONE 1	Central City Area Fully Built-up	(a) Old Town (b) City (c) Public Buildings
ZONE 2a	Compact Residential Area Fully Built-up	
ZONE 2b	Compact Residential Area 40%–70% Built-up	
ZONE 3	Suburban Areas 10%–40% Built-up	
	Industrial Areas	
	Railways, Goods Yards and Ports	
⊗	Gas, Water and Electricity Plants	

And The Ruhr

While about one third of this Industrial area is built-up, the Ruhr really consists of four cities with large partly built-up and open areas linking them together. Zones 2(b) and 3, therefore cover much more ground than vulnerable Zones 1 and 2(a). Look at your Zone Maps Ruhr I to Ruhr IV.

ZONE 2a IN THE RUHR MAKES A STRIKING COMPARISON WITH FIG. 3. THIS ZONE IS MUCH LESS VULNERABLE IN THE RUHR THAN IN LARGE CITIES. **FIG. 8** **FIG. 9**

ZONE 2b IN THE RUHR, THERE ARE RELATIVELY FEW TENEMENT BUILDINGS IN THIS ZONE WHICH IS A TRANSITION POINT BETWEEN 2(a) AND 3. **FIG. 10**

ZONE 3 SMALL BLOCKS OF MODERN FLATS GROUPED INTO SETTLEMENTS WITH SURROUNDING GARDEN SPACE ARE CHARACTERISTIC OF THE SUBURBAN AREAS OF SOME OF THE LARGE GERMAN CITIES. IT CAN EASILY BE SEEN THAT THEY ARE NOT AT ALL VULNERABLE TO I.B. ATTACK AND H.E. BOMBS WOULD BE LARGELY WASTED. CONTRAST THIS PICTURE WITH THE TENEMENT BLOCKS IN FIG. 3.

ZONE 3 THE SUBURBS OF GERMANY. THESE ROWS OF SMALL HOUSES WITH THEIR OWN GARDENS MAKE A POOR TARGET FOR EITHER I.B. OR H.E. ATTACK. THEY REPRESENT THE MORE RECENT BUILDING ON THE OUTSKIRTS OF CITIES BUT THERE IS NOT AS MUCH OF THIS AREA AS THERE IS IN ENGLAND. **FIG. 6**

ZONE 3 IN THE RUHR – GERMANY'S BLACK COUNTRY. ACTUALLY FIG. 1 SHOWS WHAT IS MOST COMMON IN THE RUHR BUT THERE ARE LARGE NUMBERS OF MINERS' SETTLEMENTS OF WHICH THE ABOVE IS A TYPICAL EXAMPLE. HOUSES STAND WITH THEIR OWN GARDENS, WHILE THE ROADS ARE LINED IN TREES. THESE ARE EVEN A POORER TARGET THAN FIG. 6.

27

Whose world is it anyway?

Individuals, societies, nations and religious groups have particular views of the world, which are reflected in maps. Any map is, of necessity, a partial view of the world; this is sometimes used disingenuously to make a particular point, or the creator of a map may inadvertently reveal things about himself or his culture.

Putting north at the top of a map has become so standard that it is easy to take it for granted. *McArthur's universal corrective map of the world*, published in Australia in 1979 (item 75), is an attempt to rectify this; it is a conventional enough world map except that it has south at the top so as to give prominence to Australia. Maps affect our view of a country's actual and metaphorical position in the world. North is clearly not really 'at the top' or Australia 'down under'. European medieval world maps usually had east at the top; Islamic maps of the same period were frequently oriented to the south. Many maps of both Oriental and Western cultures have writing facing in different directions around the map so they can be viewed from any direction.

The viewpoint from which a map is made may be expressed through something more subtle than its orientation. A map, like any other document, is an attempt to communicate what its creator feels is important, and different maps will emphasise different things. Compare the seventeenth-century Chinese and Portuguese world maps (items 66 and 42, pages 38–39); both of these in their own way show a distorted view of the world. The beautiful Chinese map of Jiujiang in Jiangxi Province (item 65, pages 34) was produced for administrative use; it highlights official buildings, major bridges and temples, and reflects the esteem enjoyed by administrators in Imperial China. Wyld's 1815 *Chart of the World shewing the religion, population and civilization of each country* (item 38) reveals a dismissive view of such major religions as Hinduism and Buddhism, both categorised as varieties of 'Idolatry and Fetichism'. To the modern viewer this is either amusing or offensive; to the mentality and culture of the time it seemed rational and indisputable.

It was also not uncommon for the wealthy to have plans drawn of their houses (item 58) and estates (items 43, 57) or routes to their homes (items 40, 60), creating maps that are literally self-centred. In a similar vein, city leaders might commission vast propagandist city views, such as the beautiful plan of Rotterdam at a time when it was the most important port of the Dutch Republic after Amsterdam (item 44). All these reflect a basic human desire to record one's position and status in the world.

The Prisoners' Press: maps printed in secret, 1944

These maps are evidence of courage and resourcefulness in the most difficult circumstances. They were printed secretly in 1944 by British prisoners-of-war in a camp at Querum near Brunswick in Germany. Philip Evans, whose son donated these maps to the British Library, was held there from 1944 until the end of the war.

A few silk maps had already been smuggled into the camp by prisoners or sent by the Ministry for Escape and Evasion. During the Second World War thousands of maps were produced by the British on silk and rayon, stronger and more easily concealed than paper, to be carried by air crew. The games company Waddington possessed the technology to print on cloth and printed many of the silk maps for supply to Allied servicemen. They also concealed maps and tiny compasses inside *Monopoly* games and packs of cards; these were sent into the prison camps, in parcels from fictitious charitable organisations. But a few maps inside a camp were of little use between 3000 men. Evans, a printer by trade, devised a method of printing more copies of the maps. The idea was to provide each man with some chance of finding his way to safety if the War ended in total anarchy, a scenario that seemed increasingly likely after the attempt on Hitler's life by a group of German army officers in 1944.

Evans's account of the map printing process and of life as a POW is truly inspiring. It also highlights how the boredom of captivity made the project seem attractive. He thought of making the maps after realising that some tiles from a bombed building in the camp could be used as printing plates; they were made of a limestone suitable for use as a lithographic stone. A camp of such a size contained someone who knew something about almost anything, including cartographers, carpenters and chemists; one of the most useful he described as a 'fixer', a natural entrepreneur who could obtain almost anything by bribery.

Printing plates and ink were improvised from very limited materials. All the information on the maps had to be drawn on by hand, in 'mirror writing' of course, using home-made wooden pens and melted margarine. The plates were treated with jelly from Red Cross parcels, and the printing press itself was made of floor boards. The roller was made from a window bar covered with leather, and ink from pitch scraped from between the flagstones of a pavement.

The standard of the resulting maps is astonishingly high. The information for the more detailed maps of the area around the camp came from reconnaissance by temporary escapees, and from a map of the area the prisoners managed to obtain. Smaller-scale maps were copied from the smuggled silk maps; up to 500 copies of each were produced.

As the camp was eventually liberated by the Allies most of the maps were never used. A few individuals had attempted to escape from the camp and taken copies of the maps with them, but how many got home will probably never be known.

[*Maps from the Prisoners' Press Archive*]. Oflag 79, Querum, nr. Brunswick, Germany: 1944. Maps C.25.a.23.

Top left: The camp and surrounding area.
Top right: Brunswick and environs.
Bottom: Northern Germany.

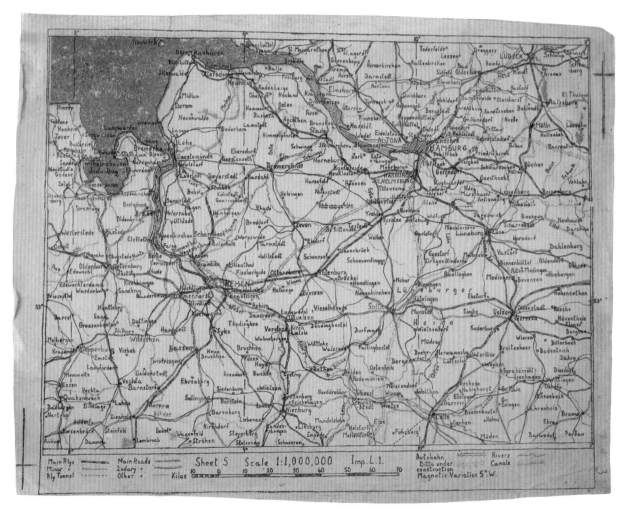

Routes from London to Luton Hoo, Bedfordshire, 1767

This elegant little atlas was commissioned by the Earl of Bute, King George III's former tutor and Prime Minister, in 1767. It shows different routes from London, where Bute spent most of his time, to his country seat at Luton Hoo, which was then being rebuilt by Robert Adam, the most fashionable architect of his day. The maps themselves reflect the splendid style in which Bute chose to live. They are closely copied from printed maps by skilled contemporary cartographers like John Rocque, but the use of colour, their tailor-made appearance and the fact that they were in manuscript moves them into a distinctly superior league. The plans name estates which lay near the different routes. This information may have made Bute's journeys more interesting. More importantly it helped him to conduct confidential negotiations on the way. Few political allies were more important than his fellow-Scot, the Earl of Mansfield, arguably the most prominent judge of the time. Mansfield had bought his estate, Kenwood, from Bute himself and was also in the process of using Robert Adam to remodel the house as an elegant villa with a magnificent library in which to receive and impress visitors.

[Road maps of routes from London to Luton Park, prepared for Lord Bute, based on printed maps by J. Roque]. 1767. Add. MS 74215.

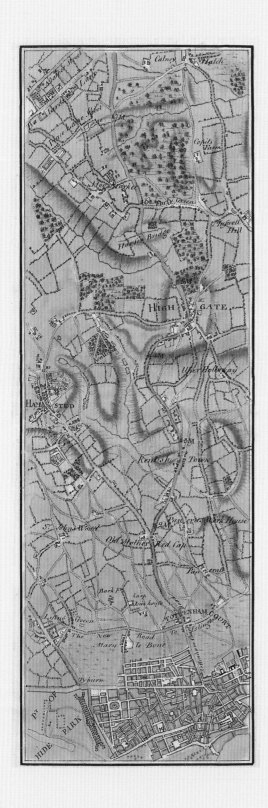

Map showing administrative divisions in Jiangxi Province, China, nineteenth century

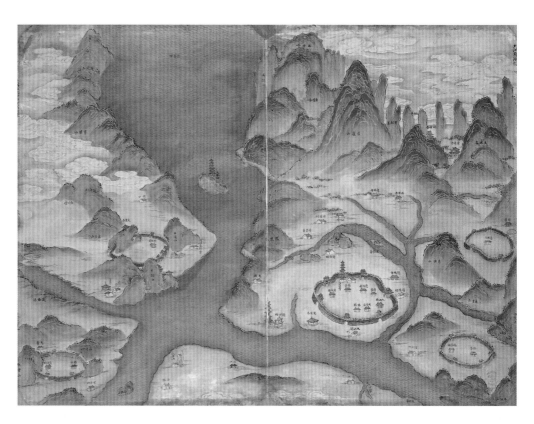

This highly decorative map actually gives an administrator's view of the province. By the time it was drawn in the nineteenth century, China's civil service, staffed by thousands of officials, had been in existence for nearly two millennia. China's vast territory was divided into provinces, prefectures and counties, each with their presiding magistrates, tax collectors and minor officials. All the administrative levels are named on this map. The buildings inside the walled cities and towns are labelled 'government office' or 'county school', for the educational system was directed towards the production of more officials. Free-standing buildings outside the towns are mostly temples, and the administrators' interest in communications is indicated by the attention paid to major bridges in this watery part of China.

[*Jiujiang in Jiangxi province: administrative divisions*]. Early nineteenth century. Add. MS 16356.

Falkland Islands by Thomas Boutflower, 1768

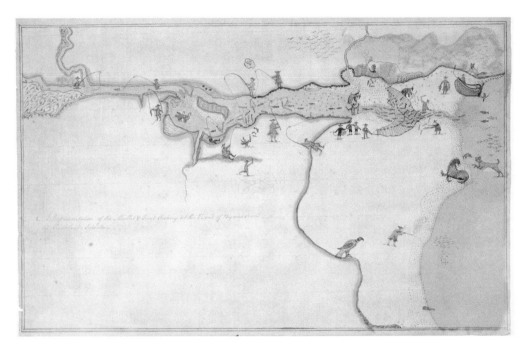

The first British settlement was established on the Falkland Islands between 1765 and 1766. A series of maps was produced by Thomas Boutflower, purser aboard HMS *Carcass* in 1768. Boutflower was not a trained cartographer as is apparent from the distorted coastal outlines and the unusual orientation with south at the top which he employed. But accurate mapmaking was not what mattered. The illustrations record some of the main occupations of the settlers – hunting, shooting and fishing. Given the harsh climate, which was unsuitable for growing crops, these were the only ways of ensuring the survival of the settlement. In 1770 the settlers were expelled by a small Spanish fleet. This almost provoked a war between Britain and Spain, which was only averted by Spain reluctantly agreeing to the settlers' return the following year.

Thomas Boutflower. [*Falkland Islands*]. [*c*.1769]. Add. MS 60333.

Map of the Vale of Kashmir, *c*.1836

This is perhaps the most striking of the early maps of Kashmir to survive. It is immediately noticeable because it is so large and beautiful. It was apparently drawn by Abdur Rahim from Bukhara (in modern Uzbekistan), who was paid the then considerable sum of 500 rupees for it. It shows Srinagar, with its famous Shalimar Gardens, on a larger scale than the rest of the map, on the Jhelum river; this is in the middle left when the map is displayed with south at the top. Other detail is impressive, distinguishing cultivated fields (light green), village groves (dark green) and bare earth (brown). Place names are all in Persian.

The map was acquired by Captain Claude Wade in 1836, who referred – 'notwithstanding the rudeness of its construction' – to the 'extreme minuteness of its information'. Receipt of the map was much welcomed by the British officials, and an expensive copy was commissioned 'on the European Model', because this provided the British with a cartographic glimpse 'beyond our frontiers'.

One thing that is evident on closer inspection is that the map does not go any particular way up. Villages are shown pictorially as little clusters of buildings and trees, and there are tiny pictures of people walking on the roads or in boats on the rivers. These all point in different directions, mainly out from Srinagar towards the edges of the map. Writing is fitted in around other features. The mountains around the outside are ringed with blue sky as if you are looking up at them. These things combine to give the feeling that the map is drawn from within Kashmir, rather than from a viewpoint above. This apparent lack of orientation is often seen in Indian and Oriental maps.

Abdur Rahim. [*Map of the Vale of Kashmir*]. [*c*.1836]. Maps S.T.K.

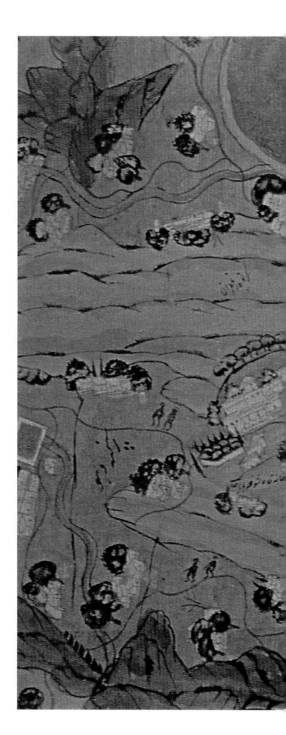

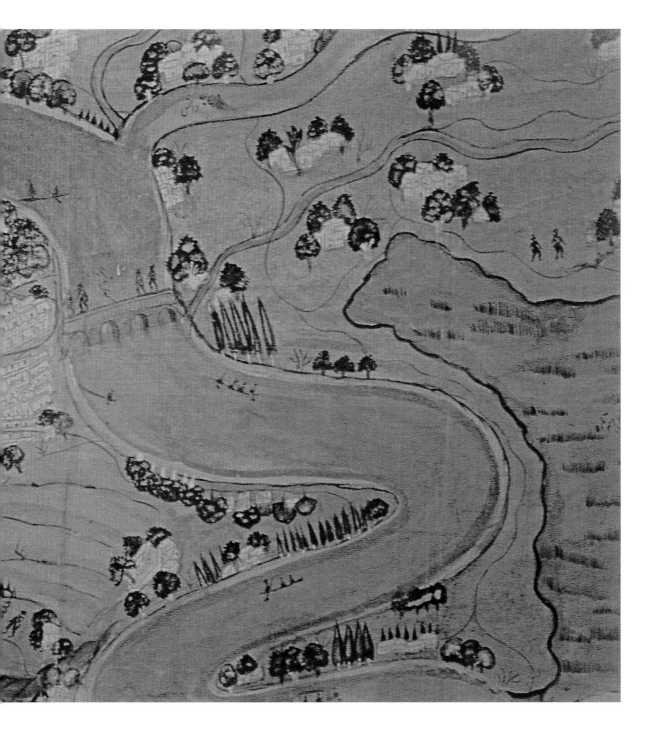

Chinese world map, 1644
& World map by Antonio Sanches, 1623

These two maps illustrate two very different world views that are the product of two different mentalities. The Chinese map looks more like a map of China than a map of the world. Most of this 'complete road map of the nine frontiers' is devoted to the depiction of China, which is placed at the centre of the world. In fact, the Chinese word for China, *Zhongguo*, means 'middle country'. The Great Wall, the river systems, and towns and cities in square and round cartouches according to rank and importance, are all laid out in the centre, and information about China's cities and provinces is provided around the sheet's edges. Other countries, some real, others imaginary, are pushed towards the margins and reduced in size: Cuba is at the top right, the mythical 'Country of Women' (as described by Marco Polo) bottom right, near what is possibly Brazil; Europe is to the top left and Africa, centre left. The disproportionate size of China reflects its importance in the day-to-day lives of its people.

At first glance, the Sanches map appears to be a far more accurate depiction of the world; the relative sizes of the known continents are more accurate, and resemble the world as we are used to perceiving it today. However, on closer examination, it is evident that, like the Chinese map, the Sanches map is also devoted to illustrating the importance of its mapmaker's native land. Again, it represents the reality of life for the Iberian people. In Spain and Portugal during this period, Imperial power was inseparable from missionary activity. This map portrays Iberian Catholicism as having a global importance. The illustrations show two Dominican priests of the Holy Inquisition; Portugal's patron saint, Anthony of Padua; and the Madonna and Child. The knight who commissioned the map is at prayer at Christ's feet. The shields of the united crowns of Portugal and Spain dominate the world beyond Europe. The iconography is effectively a demonstration of piety linked to Imperial conquest. It implies that God and the entire world are – or soon will be – both Iberian and Catholic.

Eventually, the worlds of Portugal and China would increasingly impinge on each other. Their conflicting world views – the Chinese view of China as the most advanced and important nation, and the Iberian view of themselves as destined to bring Catholicism and civilisation to the heathen – would clash. The lack of common ground in the two maps illustrated here suggests that conflict between the societies was inevitable.

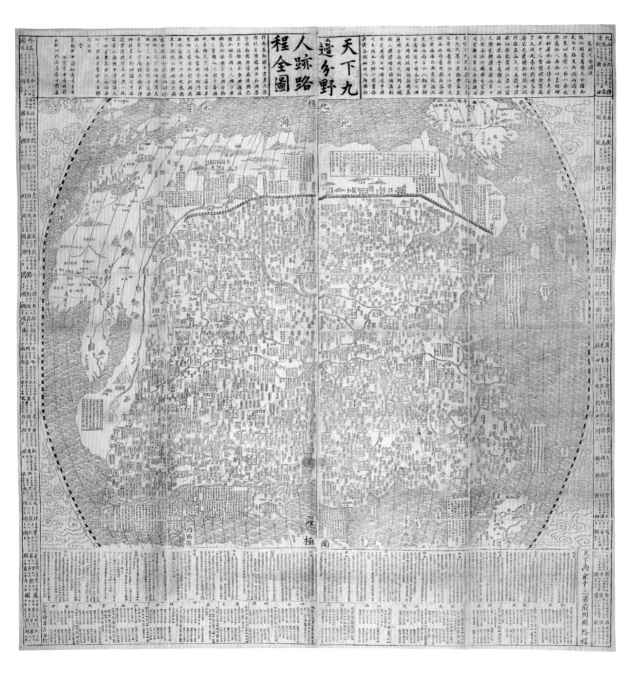

Opposite: Antonio Sanches. [*A Portuguese map of the world*].
1623. Add. MS 22874.

Above: [*Map of China and neighbouring countries*].
[Nanking], [1645]. Maps *60875.(11.)

Spinning the world

Over the past decade, historians have demonstrated many ways in which maps illustrate the saying 'knowledge is power'. Maps do not simply lead and instruct; they also mislead and deceive, in numerous ways. They can be devised with specific intent to deceive or to tell a particular version of the truth. For instance, a German map of Soviet concentration camps (item 98) was aimed at discrediting the Soviets and sowing discord among the Allies, at a time when the Germans' own concentration camps were little known in the USA and Britain. A map of the British Empire (item 84) centred 40 degrees west of Greenwich depicted Australia twice, at the south-western and south-eastern edges of the map. This made the Empire look larger than it actually was.

Reasons of national security sometimes result in maps being altered so that they do not tell the whole truth. Part of a post-war aerial photo 'mosaic' of Ayrshire (item 99, page 43) is not a photograph at all, but a painted landscape which omits the military airfield at Prestwick.

Maps can also mislead accidentally, if their cartographers are misinformed or careless. Mercator's map of the Arctic (item 89, page 42) includes the mythical island of Frisland alongside the real islands of Faeroe and Shetland. Sometimes, an error made by one cartographer can undo the accurate work of earlier carto-graphers. California had been correctly depicted as a peninsula during the sixteenth century. In 1620, a Carmelite friar produced a depiction of California

as an island. Subsequent maps would depict California as an island for over a century, an example of which is Pieter Goos's map (item 91). Maps may even mislead by omission because of their very nature – in order to be perfectly accurate and complete, a map would have to be the size of the area it represented. Thus in reality all maps contain intrinsic generalisations and omissions, which can mislead the user. Sometimes, maps need to misrepresent some aspects of a place in order to make other aspects clearer. Perhaps the most famous example of such a map is the current map of the London Underground. In order to show clearly all stations and interchanges, the usual concerns of accurate distances and directions were abandoned.

On the other hand, the instructive potential of maps should not be ignored. Jigsaw puzzles of countries and continents comprised some of the earliest commercially manufactured children's games of modern times. The Spilsbury jigsaws (item 93, pages 48–49) of the 1760s are a notable example. Maps have also been used to provide geographical education for the whole family. The map screen by Thomas Jeffreys (item 81) is ostensibly a map of the world. It is however hardly an unbiased view of the world. It starts with maps of London, Oxford and Cambridge – the centre of an educated English gentleman's world. Whatever their purpose, maps often reveal as much about the society that produced them as of the place they claim to represent.

Map of the Arctic by Mercator, 1606

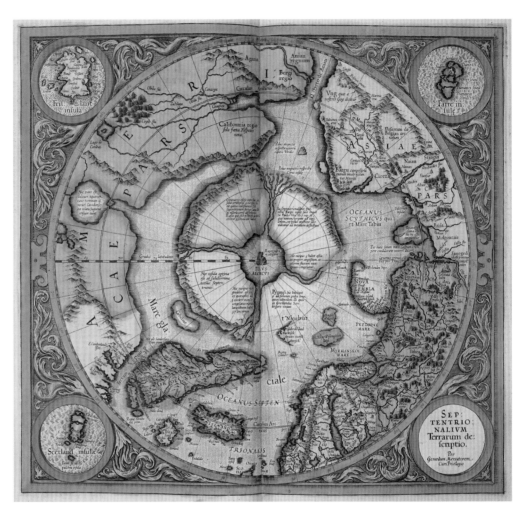

Fact, fiction and hearsay intermingle on this map showing the North Pole encircled by four islands separated by violent currents. These currents were believed to return water to the centre of the earth, where it was recycled. Three insets show the islands of Frisland, Faeroe and Shetland. Although all three are presented in the same way, Frisland was an imaginary island, whose appearance on a copy of a faked medieval map in 1558 led to decades of confusion. Frisland's coastlines and place-names are 'mapped' in detail, in accordance with the fake map.

'Septentrionalium terrarum …' from: Gerard Mercator, *Atlas sive cosmographicae meditationes* …. Amsterdam, 1619. Maps C.3.c.8.

Air photo mosaic of Ayrshire, 1946

Both these 'mosaics' were composed by Ordnance Survey from a series of air photographs taken in 1946. However only one (top right) shows the large military airfield near Prestwick. Close examination of the bottom image shows that part of the landscape is painted in and not a photograph at all on this sheet issued in 1950. The field boundaries appear sharper on the fake landscape, but they are not easy to spot. The fake map was for public sale, the genuine one only for government use.

Air photo mosaics were produced from late 1945 to update existing mapping. They were initially for official use only but one way of spreading the cost of production was to sell them to the public. In February 1950 the OS started to advertise mosaics which they republished with slight amendments to the originals. The republished mosaics were falsified either by painting in a probable landscape, or by photographing cotton wool to look like clouds over sensitive detail (such as aerodromes). In March 1951, the British Museum was warned that some earlier versions of mosaics, received on copyright deposit, should be withdrawn from public use. In January 1954, anticipating new security rules, OS decided to stop the sale of mosaics. This was possibly linked to the systematic tightening of rules after a reported scare which involved 'gentlemen with snow on their boots' trying to buy mosaics from an OS Agent.

[1:10 560 air photo mosaics of Britain, sheet 26/32 NE].
Ordnance Survey, 1946, 1950. Maps OS Mosaics.

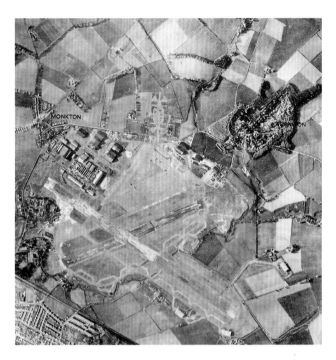

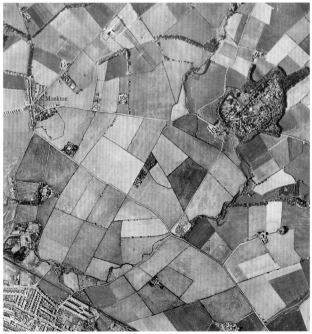

Fictitious southern continent, late sixteenth century

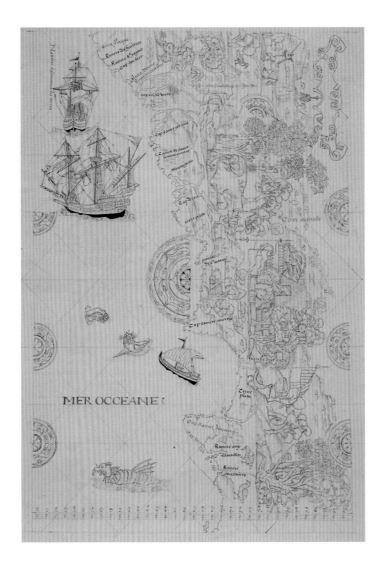

The Arctic and Antarctic were the last regions on earth to be understood. Yet many sixteenth-century world maps appear to show the Antarctic. Conceived as a theoretical landmass to balance what was known to occupy the northern hemisphere, this fictitious continent was to be spectacularly elaborated by chartmakers working in northern France. This example is from an anonymous work. Its southern continent, spread over a number of sheets like this, adds authentic looking place names to a plausibly irregular coastline. If any doubts remained, the illustrations of a largely European interior must have reassured the viewer.

[*Part of the fictitious Southern Continent, from an unsigned collection of unfinished charts*]. Probably northern France, late sixteenth century. Egerton MS 1513, f.36.

Lidice – official Czechoslovak poster, *c*.1945–46

This poster recalls one of the most appalling episodes of the Second World War. On 10 June 1942 German forces executed all the men from the Czech mining village of Lidice, west of Prague. They then deported the women and children to concentration camps, particularly Ravensbrück, with the exception of some children who were sent for adoption by loyal Nazi families inside Germany. Over the next four weeks, the village was razed so that no trace would remain. This was a reprisal for the assassination a few days earlier of Reinhard Heydrich, the German acting 'Protektor' of Bohemia and Moravia. The German plan of the village has been annotated to divide it into zones and the amount of building rubble following the demolition has been quantified. The plan was intended to assist in concealing the building rubble – and re-landscaping the site of the village – by burying it or using it for filling in the village pond and for a new road that was to run near to the site of the village. In May 1945 Czechoslovakia was recreated. This official poster attempts to smear all Germans with the taint of 'Nazi Savagery' and it states that the destruction of Lidice had been planned 'in detail and cold-bloodedly' even before Heydrich's assassination. It was produced during a period when the Czechoslovak government was forcibly expelling all Germans, regardless of political creed, from its lands. Many died from hunger, exhaustion or disease in the process and some German-speaking villages were later destroyed.

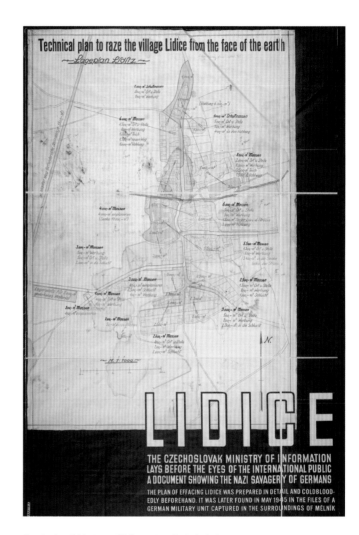

Czechoslovak Ministry of Information. *Technical plan to raze the village Lidice from the face of the earth.* Prague, [1945–6]. Maps 27535.(5.)

Maps of the British Isles by the Visscher family, *c.*1620 & *c.*1670

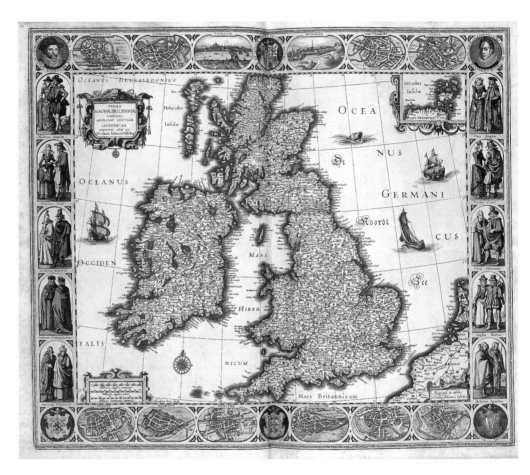

The two maps shown here were produced by members of the Visscher family, a distinguished line of Amsterdam map publishers. The one above was issued by Claes Janszoon Visscher about 1620; the version opposite by his son Nicholaes, probably in the 1670s. Their maps reflect the changes in decorative style of the intervening half century. They also reveal a change in the popular attitude towards maps, from broadly encyclopaedic to more consciously scientific. Vignettes containing portraits, fashion plates, town views and discreet constitutional and economic references through the selection of portraits, towns and social classes from King James I and London downwards give way to a more simple, though still decorative, depiction of geography. What is less obvious is that both maps are printed from the same copper-plate, which is given away by the lettering 'Oceanus Germanicus'. Out-of-date artistic style would be spotted by anybody, but perhaps not out-of-date geography. Replacing the decorative side panels must have involved considerable work. All the old detail had to be carefully hammered out and the new elements engraved. But at least the younger Visscher avoided having to re-engrave the dense geographical detail.

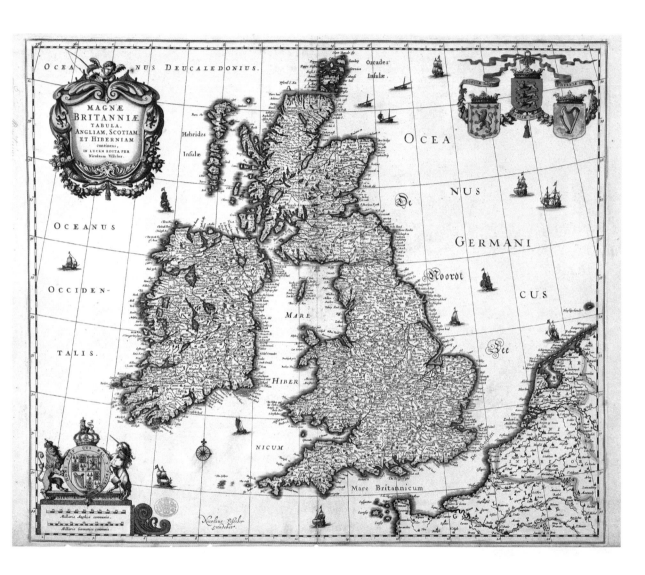

Opposite: Claes Janszoon Visscher. *Tabula Magnæ Britanniæ....* [Amsterdam], [*c.*1620]. Maps C.3.c.9.

Above: Nicholaes Visscher. *Magnæ Britanniæ tabula, Angliam, Scotiam et Hiberniam continens.* [Amsterdam], [*c.*1670]. Maps K.Top.5.5.

Jigsaw puzzle by John Spilsbury, 1766

During the mid-eighteenth century, the first English board games for children began to be produced by commercial firms. The games included dissected puzzles. These were invariably maps which had been cut into pieces around political borders and then pasted onto boards. They were intended for use as aids in teaching geography.

The earliest commercial puzzles seem to have been produced by a young London engraver, John Spilsbury. By 1763 he was offering a long list of dissected maps for sale but it is likely that these were the maps of other publishers that he would cut up, mount and box to order. A few years later Spilsbury became the first person to create maps for the express purpose of dissecting them to make puzzles for sale. These maps were accompanied by key maps. Only eight dissected maps are known with his imprint: the world, four continents, England & Wales, Ireland and Scotland. Europe is dated 1766, the seven others, 1767.

This map of Europe belongs to a set of four dissected maps of the continents then known (i.e. excluding Australia). Each of the maps of the continents fits inside a standard oak box, with the title repeated on the outside of the lid and a small key map pasted to the inside.

Spilsbury's dissected maps lacked the interlocking pieces of modern jigsaws, which would begin to appear from the early 1780s.

John Spilsbury. *Europe divided into its kingdoms 1766*. London, 1766–77. Maps 188.v.12.

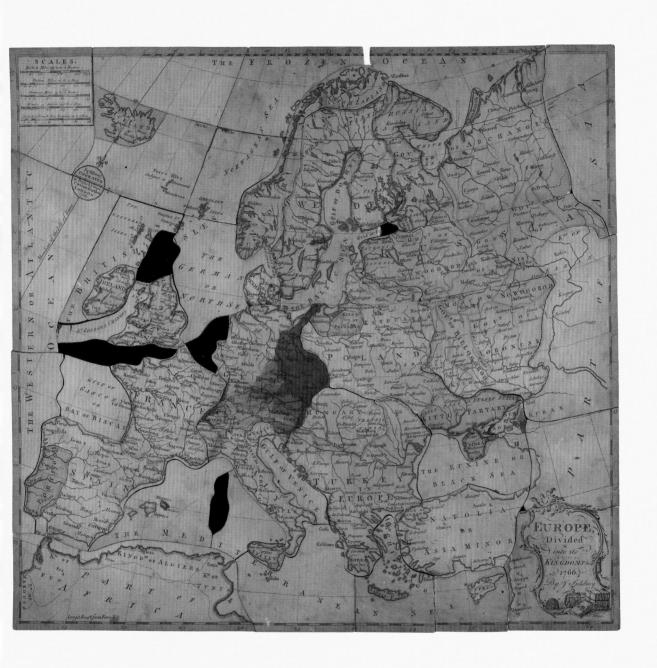

EUROPE, Divided into its KINGDOMS &c. 1766. By J. Salisbury

Take a closer look

Unlike the maps in the previous three sections those displayed here have a less obvious meaning. Some of these features would have been intended for a very select audience, while in other cases the message was more transparent to contemporaries even if it is less clear today.

The cartographers who in 1924 drew contours in the shape of an elephant to save them the effort of actually surveying inaccessible hills in what is now Ghana (item 113, page 56) must have hoped that nobody would spot their shortcut. Although a serious scientific effort by the pioneer astronomer Giovanni Domenico Cassini, his 1679 map of the Moon (item 123, page 57) was 'improved' by turning a promontory into a woman's head. One imagines that the astronomer or engraver intended this feature to be spotted by the subject and no-one else. The contrary sin of omission is demonstrated in the 1675 map (item 112) of Barbados. The mapmaker Richard Forde, being a Quaker, defied instructions to show fortifications which his faith opposed.

In some cases the message of the map was all too obvious. The atlas (item 111, pages 54–55) commissioned in 1558 by the Catholic Mary Tudor of England, but left incomplete at her death, became the property of her Protestant successor Elizabeth. Her hatred of Mary's husband, Philip II of Spain, may have caused her to scratch out Philip's coat of arms from the map shown here. Elizabeth's father, Henry VIII, was more pleased with the 1539 map (item 121) showing an intended route to bring Anne of Cleves from her native Flanders to England.

The bombastic celebratory prose on Jacques Callot's 1631 map (item 120, page 58) was designed to celebrate the victory of the French King Louis XIII at the 1627–28 siege of La Rochelle. However, the triumphal tone is somewhat undermined by the etcher including scenes showing the grim reality of siege warfare.

McDonald Gill's 1914 *Wonderground Map of London* (item 122) is not the most practical of maps for finding your way around London. This lack of functionality is of no consequence when set against the countless incidental details of London's less obvious attractions.

The 'philosophico-chorographical' chart of Kent produced in 1743 by local physician Christopher Packe (item 117, page 53) has some remarkable parallels with a map of a north-east province of Korea (item 133) produced over half a century later. Both maps show their areas as a network of veins. Packe shows a model of Kent similar to the body's circulatory system while the Korean map traces mythical life-forces across the land.

The sequence of four Soviet maps (item 127, page 60) at various scales ranging from the whole of south-eastern England down to the Dartford Tunnel demonstrate that the wider the field of vision the less detail you see. Needless to say, the opposite is also true.

Map of China by Hokusai, 1840

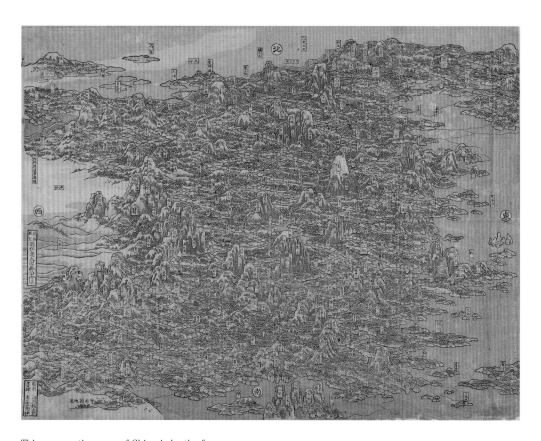

This perspective map of China is by the famous Japanese artist Hokusai (1760–1849). With its detailed representations of cities, mountains and major landmarks – for example the Great Wall of China which can be seen snaking its way across the top – this map may appear to be the result of careful observation but in fact Hokusai never went to China. It is signed by Hokusai under the comic name 'Manji, the old man mad about drawing aged 81'.

Katsushika Hokusai. *Todo ichiranzu* [*view of China*]. [Seiundo, Japan],[1840]. Maps 188.v.3.

Chart of Kent, 1743

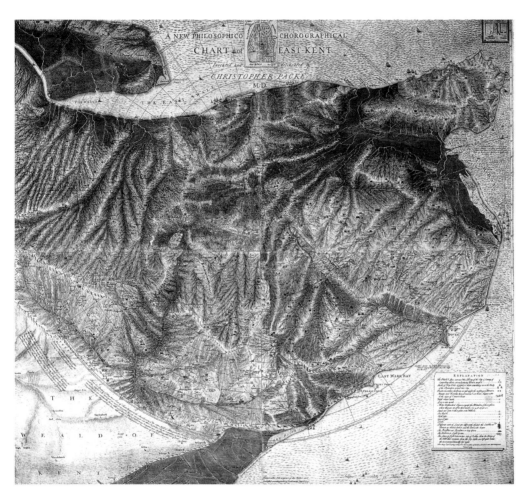

A map can inevitably be influenced by the ideas, profession and culture of the mapmaker. A good example is this 'philosophico-chorographical' chart of Kent by Canterbury physician Christopher Packe. The main feature is the interrelationship of streams, hills and valleys which he considered to be analogous to the body's circulatory system, resulting in the resemblance of the drainage in the valleys to blood vessels and arteries. It is thus a 'philosophical' map based on the traditional belief that the character of the universe is reflected in the human body.

Christopher Packe. *A new philosophico-chorographical chart of East-Kent*. [Canterbury],1743. Maps K.Top.6.24.11.Tab. End.

Map of the British Isles & Western Europe, 1558

Wilful damage is not perhaps what you would expect to find on an exquisite atlas that had been the property of royalty. Yet this beautiful map of the British Isles and Western Europe appears to have been the victim of royal anger at what it represented. The left side of the heraldic shield over England has been scratched out.

In order to determine who had the motive and opportunity to do this, it is useful to consider the map's provenance. The map is part of the atlas known as the Queen Mary Atlas. In 1558, Queen Mary I of England commissioned the atlas from the Portuguese mapmaker Diego Homen. It was probably intended as a gift for Mary's husband, King Philip II of Spain. Mary died before the atlas was finished. After her death, the atlas was presented to Elizabeth I, Mary's successor to the English throne.

By the time of Mary's death, the heraldic shield had already been placed over England. The shield contains Mary's coat-of-arms on the right: lions quartering the fleurs-de-lis. Philip's coat-of-arms, on the left, has been scratched out. The sight of the arms of Catholic Spain emblazoned over England would have been anathema to the new Protestant queen. Elizabeth's hatred of Philip, together with her temper, may well have led her to scrape Philip's coat-of-arms off the map.

Diego Homen. *The British Isles and Western Europe.* 1558.
Add. MS. 5415A, *f.*5

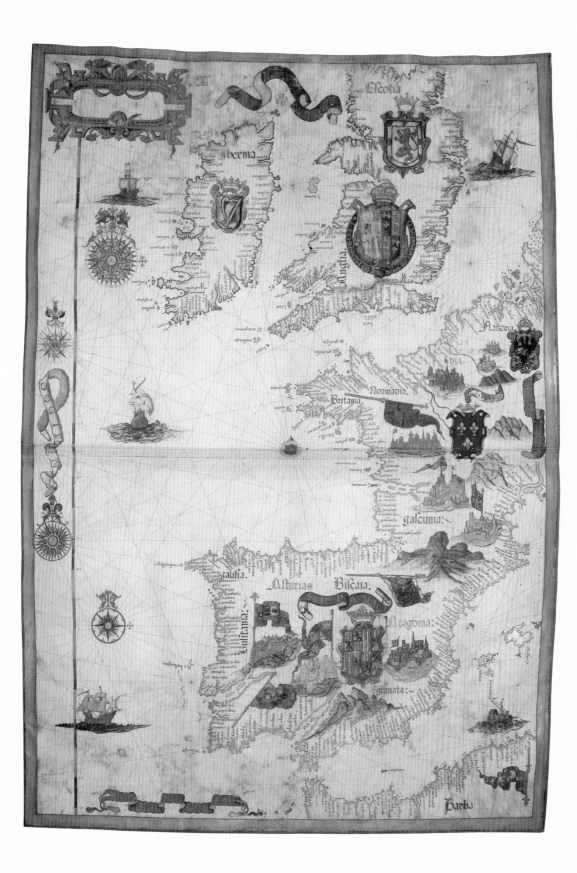

Little surprises: the elephant and the maiden, 1924 and *c*.1679

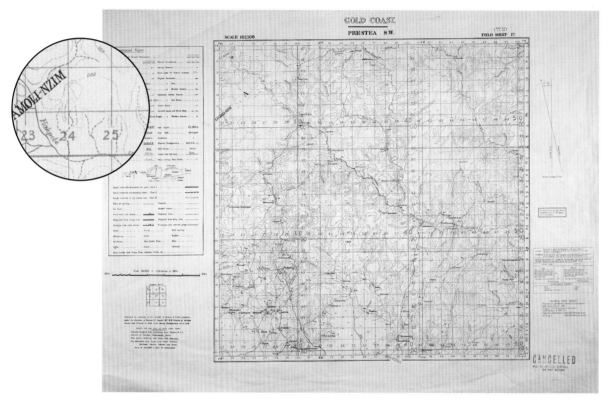

In 1924 a group of young Army officers were surveying an inaccessible part of Africa's Gold Coast (now Ghana). At the end of a hard day's work under the tropical sun, a single hill remained. The men decided that, using a little imagination, the small area could be artificially filled in. They drew round a picture in a magazine, creating contours in the form of an elephant. Their improvisation was not detected and the elephant can be seen at least into the 1960s.

The first scientific map of the moon was produced in Paris by the renowned astronomer Giovanni Domenico Cassini, who was lured to France by Louis XIV. From observations through a telescope in the 1670s he built up a completely recognisable picture of the lunar surface. As a result, the nearside of the moon was better understood than much of the earth's surface. But what then is the 'Moon Maiden' doing on the map? The Heraclides Promontory (in the lower right centre) has been turned into a woman's head. Who was she and who put her there? Was it Cassini himself or the map's celebrated engraver, Claude Mellan, who was 81 years old at the time?

Above: Gold Coast Survey. *Gold Coast 1:62,500, sheet 17.* Accra, 1924. Maps 65330.(25.)

Opposite: Giovanni Domenico Cassini. *Carte de la lune.* Paris, [*c*.1679, reissued 1787]. Maps K.Top.1.88.

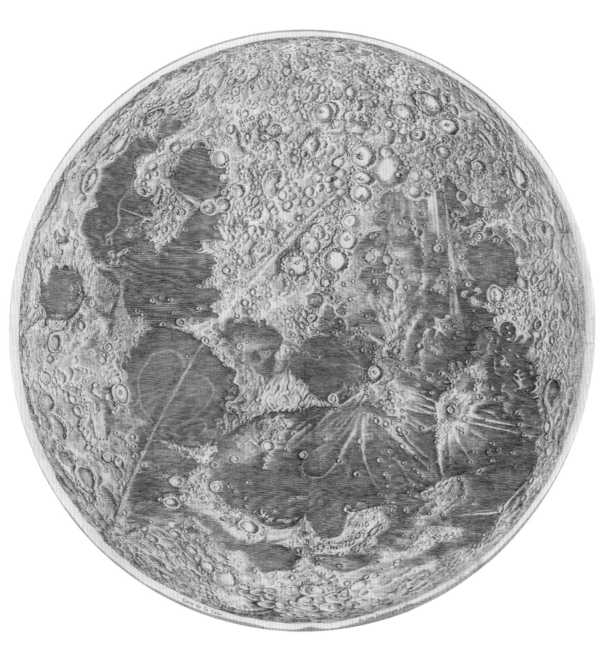

Carte de la Lune de Jean Dominique Cassini

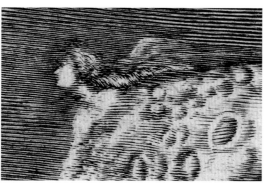

The siege of La Rochelle by Jacques Callot, 1631

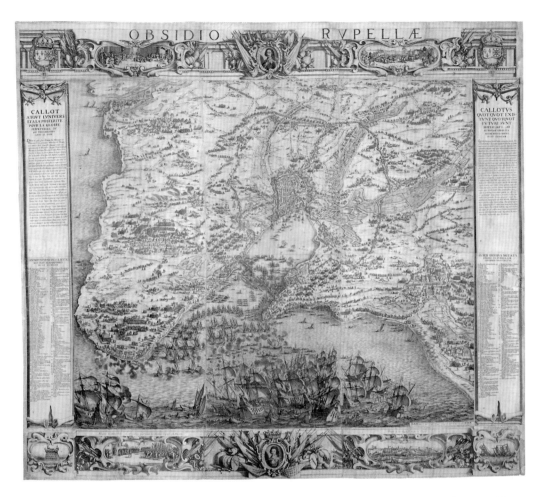

Politicians have often used famous artists for their own ends, but rarely more blatantly than here. This map, commissioned by the leading French minister, Cardinal Richelieu, commemorates the siege of La Rochelle in 1627–28, immortalised in Alexandre Dumas's novel, *The Three Musketeers*, when the royal forces of Louis XIII conquered the French Protestant stronghold. In the side texts Callot, the leading etcher of his day, addresses himself, apparently personally, in French and Latin 'to the universe and posterity

for the perpetual glory of the Most Christian King Louis XIII'. The map focuses on the defeat of the English naval forces that had tried to break the royalist blockade. Callot's true feelings are hinted at in the sometimes gruesome miniature depictions of military life. At the time he was also etching the series of small prints illustrating the miseries of war for which he is now famous.

Jacques Callot. *Obsidio Rupeliae*. Paris, 1631. Maps STR.

The 'Christian Knight' world map, *c.*1596

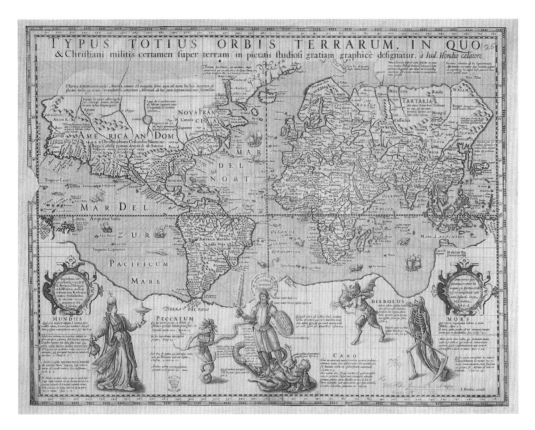

From the 1560s to 1648 the Netherlands was engaged in a war of independence from Catholic Spain. Jodocus Hondius, this map's creator, was a Dutch Protestant. The map's title, '…map … in which the struggle of the Christian Knight on Earth … is graphically depicted', suggests that it is an allegory of a real battle. The human figures illustrate the battle between Catholics and Protestants. The armoured 'Christian' knight resembles King Henry IV of France, a Protestant ally. He is battling symbolic representatives of Catholicism: (left to right) Worldly Vanity, Sin, Carnal Weakness, the Devil, and Death.

Jodocus Hondius the Elder. *Typus totius Orbis Terrarum*….
[Amsterdam, 1596?]. Maps 188.k.1.(5.)

Russian map of the Thames Estuary & Dartford Tunnel, 1977

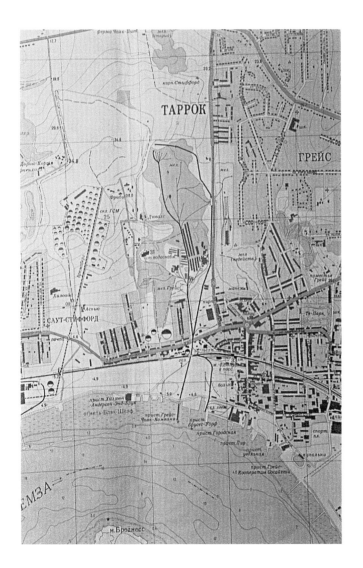

This map looks unusual but strangely familiar. It shows the area east of London, England, near the Dartford Tunnel – but it's in Russian. Unknown outside the Eastern Bloc, the Soviet military mapped much of the world at several scales. Many of the maps are backed with detailed information about the area depicted: climate; population; roads, railroads, bridges, their widths and capacities; forest cover, down to the types of trees and the clearance between them; even the number of telephones in each village – so much information that you wonder if they were planning to mount an invasion. After the fall of Communism in the Soviet Union, the new Russian government needed to bring in some hard cash in a hurry, and suddenly their secret military mapping – previously unknown in the West – started to appear on the market. At first the sale of the maps was a little cloak-and-dagger, and it took a while before the Russians understood how best to make a deal (they started by offering a discount only if 100 copies of the same sheet were purchased, which libraries don't do). But eventually it gave map libraries the opportunity to buy coverage of places such as China, India, most of Africa, and the Soviet Union itself, which had been almost impossible to get before.

Union of Soviet Socialist Republics, Army, General Staff. 1:10,000 Tarrok i Greivzend [Thurrock and Gravesend]. 1977. Maps X.3250.

List of items exhibited in *Lie of the Land*

All items exhibited in *Lie of the Land* come from the collections of The British Library. Please note the departmental locations of items according to the press-mark prefix:

Maps = Map Library; IC, IOR, OIOC, OR, ORB = Oriental and India Office Collections (OIOC); Add. MS, Cotton MS, Cotton Augustus MS, Egerton MS, Harley MS, Royal MS = Department of Manu-scripts; no prefix = General Collections.

DRAWING THE LINE

1 Yang Ma-no and Long Hua-min [i.e. Manuel Dias and Nicolo Longobardi]. [*Chinese terrestrial globe*]. [1623]. Maps G.35.

2 'A general draught of the contents of this manu-script it being a description of the sea coast from the mouth of California to the straits of Lemaire' from: William Hack. *Description of the Coast & Islands in the South Sea of America*. 1698. Maps 7.Tab.122.(1).

3 'St. Iago' from: William Hack. '*Description of the Coast & Islands in the South Sea of America*'. 1698. Maps 7.Tab.122.(9).

4 'Descriptive map of London poverty 1889 (south-west sheet)' from: Charles Booth (editor). *Labour and life of the people of London* Appendix to Vol. II. London, 1891. Maps C.21.a.18.

5 'Disposition of the troops and general view of the patroles in and about London on account of the riots in 1780' by R. Parr in: *Plans of encampments and dispositions of the army in Great Britain from 1778 to 1782*. Add. MS 15533, f.39.

6 Charles Goad. *Insurance plan of City of London*. Vol. 1, sheet 10. Scale: 1:480 (40 feet to 1 inch). London, 1886. Maps 145.b.22.

7 Ordnance Survey. *Plan of London*. Extended Series, sheet VII 65. 1894–95. Scale: 1:1056 (5 feet to 1 mile). Maps O.S.

8 William Lambarde. *Beacons in Kent*. 1585. Add.MS 62935.

9 [Map of Lancashire] from: *Burghley-Saxton Atlas*. [*c*.1579]. Royal MS 18 D. III, *f*.82.

10 Germany, Heer, Vermessungs- und Kartographis-che Abteilung. *Luftbildstellungskarte, stand 7.IV.45. 1:10 000*. Stabsbildabteilung A.O.K., 1945. Maps Y.3115.

11 Wilfried Krallert. *Volkstumkarte der Slowakei, blatt 5*. Vienna, 1941. Maps Y.1911.

12 J.I. Lenke. 'Aufmarsch der Politischen Leiter Reichsparteitag 1939 Zeppelinwiese', overprinted on Leonhard Amersdorfer. *Plan von Nürnberg-Fürth*. Add. MS 63747A.

13 United States Office of Strategic Services. *Billeting and control facilities for displaced persons Hannover and Bremen, 26 February 1945*. Branch of Research and Analysis, 1945. Maps 26907.(192.).

14 John Rogers. *Boleine with the French Fortresse and the Country towards Hardilo*. [*c*.1546]. Cotton MS Augustus I.ii.77.

15 [*Map of Dauphiné, Provence and Piedmont*]. [*c*.1707]. Add. MS 71065.

16 Deutsches Archiv für Landes und Volksforschung. *Die Siedlungsgebiete der Deutschen in der Tsche-choslowakei* [with German occupation line in Czechoslovakia as of 5 October 1938 overprinted]. Leipzig, 1938. Maps X.2564.

17 *Map of Munster prepared for the purpose of presenting … the state of this disturbed and distressed province by … N.P. Leader*. [1827–8]. Add. MS 63632.

18 Patricke Ragett. *The greatest part contiguous of the Barony of Philipstown in the Kings County* [*Leinster*], *E. Lucas deliniavit* [*from the Down Survey of Ireland*]. Add. MS 72869, ff.72v–75.

19 [Anthony Anthony]. [Attack on Brighton,1514]. [1538–9]. Cotton MS Augustus I.i.18.

20 Great Britain, War Office, General Staff, Geographi-cal Section. *The County of London, G.S.G.S. no. 3786A* [*east sheet*]. Scale 1:20 000. Ordnance Survey, 1926. Maps CC.5a.170.

21 Germany, Generalstab des Heeres, Abteilung für Kriegskarten und Vermessungswesen (IV. Mil.-Geo.). *Militärgeographische Einzelangaben über England. Stadtplan von Plymouth*. Berlin, General-stab des Heeres, 1941. Maps 47.g.14.

22 *Einwanderer erster und zweiter Generation aus Mittel- und Westeuropa*. Stuttgart and Hamburg, G. Hulbe, [1940–1]. Maps X.3817.

23 *Übersichtskarte zur Geländebeurteilung von Mitteldalmatien, Sonderausgabe Panzerkarte*. Pz. A.O.K., 1944. Maps X.5433.

24 Germany, Luftwaffe, Generalstab. [*Great Britain bombing maps*.] 1941. Maps Y.415.

25 Great Britain, Air Ministry. *Zone maps, typical examples of city zones, A.M. 407/2*. [194-]. Maps X.5429.

26 Great Britain, Air Ministry. *Zone maps, series GSGS 4399 (Dresden sheet)*. 1943. Maps MOD GSGS 4399.